ARTS COUNCIL
OF GREAT BRITAIN

Modern
BRITISH PHOTOGRAPHY 1919-39

Museum of Modern Art, Oxford 27 July – 31 August 1980

Leeds Polytechnic Gallery 27 September – 2 November 1980

Library Concourse, University of East Anglia
10 November – 7 December 1980

Gardner Centre Gallery, University of Sussex
18 December – 8 January 1981

Bolton Museum and Art Gallery 17 January – 14 February 1981

City Museum and Art Gallery, Worcester
21 February – 14 March 1981

Newport Museum and Art Gallery 28 March – 25 April 1981

Contents

In 1978 the Arts Council mounted the exhibition *Pictorial Photography in Britain 1900–1920*. The present exhibition treats the immediately subsequent period.

Modern British Photography 1919–1939 has been selected and researched by David Mellor who has also written an essay on the photography of the period for the catalogue. David Mellor has been assisted in his research by Terence Pepper of the National Portrait Gallery who has supplied the biographical information for the catalogue; our thanks go to them both. We would also like to express our gratitude to the many lenders to the exhibition, both public and private, who are listed elsewhere in this catalogue.

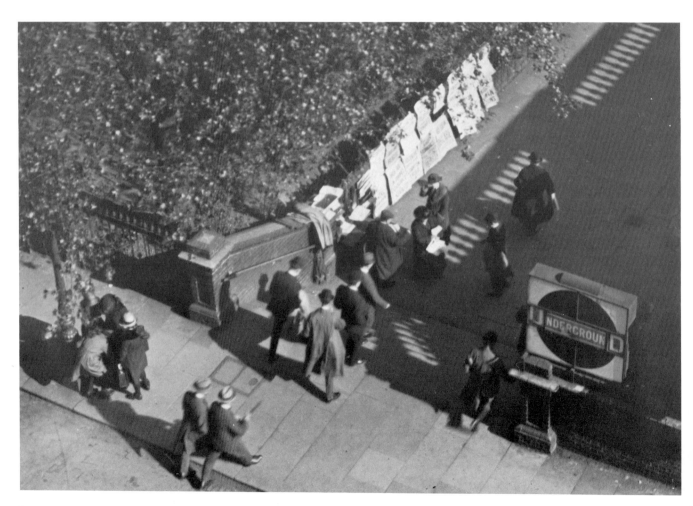

Modern British Photography 1919-39

AN INTRODUCTION TO THE PERIOD BY DAVID MELLOR

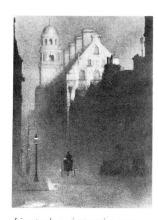

Liverpool: an impression 1907
J Dudley Johnston

June Evening circa 1920
Ward Muir
(left)

THE DECLINE OF
PICTORIALISM AND THE
RISE OF 'STRAIGHT'
PHOTOGRAPHY

Between the two World Wars, British photography was shaped by changing economic, technical and cultural forces that moulded the functions and style of the photographs themselves. Photographers were adjusting, in the first place, to the formation of the mass media, resisting or conforming to new commercial structures. Professional portraitists were faced with a contracting market that could only, it seemed, be widened by adopting novel styles; on the other hand fashion and advertising photography offered steadily rising professional roles. Painter-photographer amateurs experimented and were drawn into advertising, while the area of Realist reportage began to expand in the second half of the period. These were the major currents, and some photographers managed to move between each of them, adapting and hybridizing the separate strands of portraiture, experimentation, advertising photography, fashion and reportage.

This new professional framework for photography developed at the same time as Pictorial photography declined; indeed it had already begun to collapse before the Great War. The devices of Pictorialism – soft focus, manipulation and retouching the photograph, along with decorous subject matter – were steadily displaced as the 'twenties continued. A good part of modern British photography between 1919 and 1939 was primarily concerned with the erosion of Pictorialism. The first major initiative came in September 1919 with Ward Muir's exhibition at the Camera Club, called *The Fact of Beauty*. There, the seventy photographs and his written polemics carried forward the case for 'straight' photography. Muir opposed the fictional blurrings and softenings of Pictorialism; 'my contention is that photography deals with facts. . . as soon as we start altering facts, we start altering photography'.[1]

In the controversy that followed he was supported by a significant ally – the photographic industry – who asserted a populist, mass media role for 'straight' photography and endorsed Muir's anti-Pictorialism: 'millions of our fellow Britons are proving daily that their preference is for the straight and unfaked hand camera photograph. They prove their choice by buying millions of "picture papers" every day. Because throughout the world an interest in straight and true and real honest to goodness photographs is tingling through the very limb and tissue of our modern, interested age'.[2] This attempt to rally the 'millions' in their supposed preference for the kind of factualist photography embodied in Ward Muir's direct prints and unretouched negatives of commonplace subjects, stood in opposition to the Pictorialist

position. One prominent Pictorialist, F C Tilney, denounced Muir's awkward unpicturesqueness, writing that he had 'deliberately cut himself off from the picture nurtured section of the world and took his stand, as nearly as he could, at the uninitiated savage's viewpoint'.[3] Muir's departure into 'straight' photography at the beginning of the 'twenties was a rehearsal of Documentary photography, in the mid-and late-'thirties. Because, in terms of subject matter and point of view, Muir had argued for an urban industrial iconography of 'gasometers, factory chimneys',[4] treated as 'facts' of modern life. His picture, *June Evening* (1919), marked a break in British photography. The difference between Pictorialism and the new, 'straight' photography can be seen in the contrast between the amorphous atmospherics and orthodox view point of J Dudley Johnston's *Liverpool; An Impression* (1907), and the assymetrics, high view point and distanced urban realism of *June Evening*, an independent forerunner to the work of Moholy-Nagy, and importantly, linked to Paul Strand.[5] But Muir's example in the early 'twenties was not immediately taken up, it lacked the context of a vanguardist climate that was present in contemporary New York, and it was only ten or more years later, after Muir's death in 1927, that the factualist aesthetic was renewed and became a major force in British photography.

PARK'S CUBIST PORTRAITURE

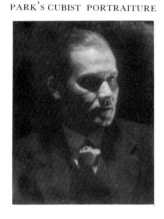

C R W Nevinson 1919
Betram Park

THE DRIFT FROM
RETOUCHED PHOTOGRAPHY

1919 was an experimental year, with Muir's anti-Pictorialist intervention and also the display of Bertram Park's portraits where he used a repertory of geometrical forms associated with the Great War, drawn from 'dazzle' camouflage and Nevinson's cubist war paintings.

Here were the beginnings of a tendency which Beaton, Tanqueray, McBean and many others would further extend:- the derivation, from Modernist painting, of decorative solutions to portrait photography: in essence, a kind of reinvigorated Pictorialism. However, these borrowings used to supplement Park's portraits, like *C R W Nevinson* (1919), were felt to be beyond the conservative Pictorialist norm: 'It seems as if Mr Park were obsessed by the Cubist school, otherwise he would surely not run after it as he does...' one commentator wrote.[6] In 1920 Park made a portrait of Ward Muir along the same lines and the irony of such a contrived portrayal was not lost on spectators.... 'That this deadly sort of control should be applied to the arch apostle of straightness is distinctly unkind'.[7]

Park had retouched both the *C R W Nevinson* and *Ward Muir* photographs in a way wholly contrary to the ethos of retouching portraits; he had drawn in and emphasised harsh angles, creases of light and shadow, not moderating and erasing them into a melting softness following the conventional practice. Dorothy Wilding, a leading portraitist of the period, defended retouching, in horror at the notion of direct prints from straight negatives. 'If you have seen a contact print of an untouched negative... the effect is quite grotesque... the unfair exaggerations have to be removed without the subtle personality of the face being in any way lost.'[8] When she combined this tactic of retouching, with posing sitters like *Noel Coward* (1925),[9] in profile or grouped friezelike,[10] the effect was one of finely graded tones distributed across a low relief stone surface, or a plaster medallion.

Meanwhile another portraitist, Herbert Lambert, joined the drift that had been signalled by Muir away from retouching and soft focus presentation. By the mid 'twenties Lambert was

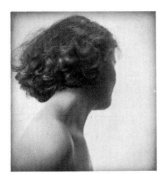

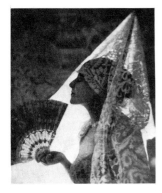

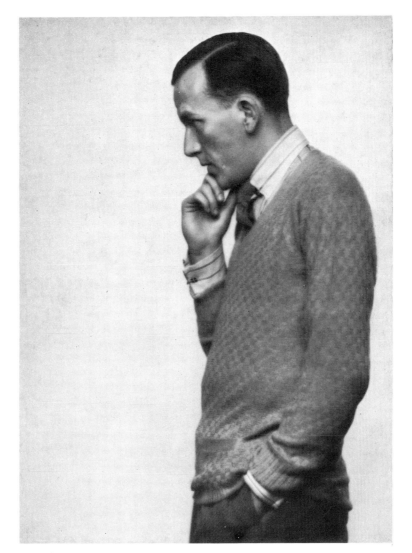

Girls Head circa 1922
Herbert Lambert
(top)

Portrait
Baron de Meyer
(above)

Noel Coward 1925
Dorothy Wilding

advocating 'straight' photography, proposing the model of Holbein's precise portraiture:[11]. . . . 'sharp definition seems to present just as many delightful possibilities as the vague, dreary sentimentalism of the soft focus'.[12] With *Girl's Head* (circa 1922), Lambert's naturalism looked forward to Hoyningen-Huene's fashion photography of around 1930.[13] In part, what Lambert was doing was similar to Hoyningen-Huene's later role: effecting a reaction against Pictorialism away from, for example, the diffuse luxuriant photography of Baron de Meyer.[14]

E O Hoppé, astute, alert but no radical, had nevertheless perceived a coming crisis – involving the challenge of the mass media, the rise of a highly developed commercial photography and the decline of studio portraiture. Hoppé responded by becoming an international photographer through establishing studios in New York (just after the Great War) and in Berlin (in 1927). He rationalised his business by forming a picture agency in 1920 that distributed his photographs on a vast scale: he began to produce photobooks, travel books, collections of human types and city surveys. He diversified too, becoming an industrial photographer as well as publicist for film companies and photo-journalist.

Around 1921 Hoppé photographed working class women, flower sellers and chars. The photographs then appeared in Hoppé's enormous Goupil Gallery exhibition the following year, in the section, 'Human Documents'; they were Hoppé's more picturesque counterparts to Paul Strand's harrowed street faces of 1917.[15] The subsequent use of these 1921 portraits demonstrates Hoppé's flexibility in adapting to the changing functions of photography, in this case the mass circulation use and re-use of documentary images. In 1922 and in 1926 they were included in books, (*Taken from Life* and *London Types Taken from Life*), and in 1935 the same flowerladies were recycled through his agency and came to rest on the back cover of the new large circulation photo-magazine, *Weekly Illustrated*, in a full page feature, 'Old Ladies'.[16]

It was probably through his contact with more developed American attitudes towards commercial photography that Hoppé diversified and extended his narrow pre-war photographic practice. The rewards for selling photography, like paintings and books, to America – especially in the period 1919–29 – were high. Certainly by the end of the 1920's much of the British culture industry was dependant upon an American market.[17] American influence was pervasive at all levels during the inter-war period, and an important colony of American photographers, including Francis Bruguière, Curtis Moffat, Paul Outerbridge and Francis Feist were intermittently in London during the 'twenties.

But the most senior American photographer resident at this time in Britain, Alvin Langdon Coburn, had all but abandoned photography. Throughout Coburn's lectures and writings in the 'twenties, images of spiritual radiance and unearthly light recurred, shielding him from the realities of the post war world. 'There are moments in this modern world of ours when the return of the Golden Age seems a very remote possibility, but it is not as hopeless as it seems. Everywhere amidst the darkness of materialism are gleams of light'.[18] Coburn's transcendental and subjectivist theories may now appear anachronistic when contrasted with the rise of a 'straight' objective aesthetic. However in his obsession with light, he was close to the experimentalism of Francis Bruguière and Curtis Moffat. The latter's first 'Paintings with Light'[19] were made in 1924, and in a contemporary interview, Moffat distinguished his abstract Rayograph compositions from any concern with naturalism. 'While photography is essentially realistic, this work is absolutely unrealistic, it has nothing to do with mechanical vision'.[20] Yet Moffat's painter-photographer endeavour was self consciously Modernist in its concentration upon the most elementary photographic means, photography without a lens, by simply placing objects upon light sensitised paper, therefore bypassing the conventional

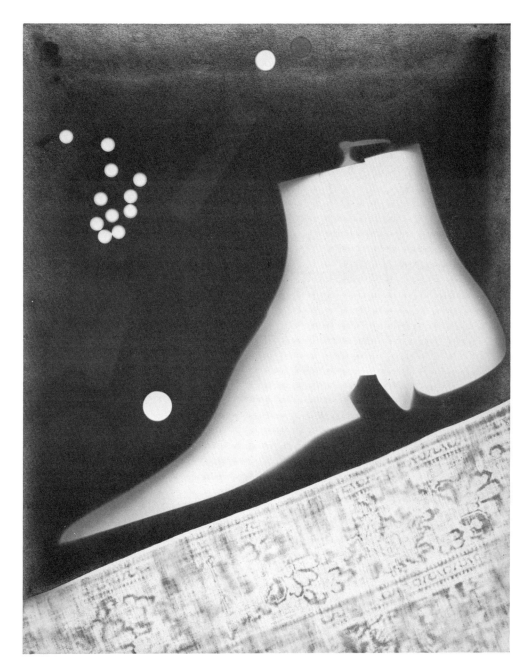

Rayograph 1924
Curtis Moffat

camera. Establishing his London studio in February 1925, Moffat imported those methods he had learned through two years sustained contact with the Dada and Surrealists in the Parisian avant-garde, (principally with Man Ray, with whom he had developed 'painting with light' – Rayograph compositions).

Moffat exhibited his abstract compositions in London in two key exhibitions with Olivia Wyndham in 1925 and again in 1926. However, it was more probably through magazine reproductions of Man Ray's Rayographs in *Vogue* in 1925[21] that Cecil Beaton grasped the possibilities for decorative images that bypassed conventional photographic methods. As Beaton related in his diary in December 1926:. . .'in an experimental mood [1] decided to make dada-like designs by placing various objects on sensitised paper. It was my first attempt at this sort of thing. . . using. . . bits of chandelier, wire-netting, a dishcloth, pieces of cotton, matches, vases, brooches, and spikey coral necklaces. . . . It was fascinating to produce such contrasting tones and subtle textures, much finer than the results from any lens photograph. . .'.[22] 'Painting in light' was a paradigm of 'straight', untouched photography, tracing chosen common objects with a result that was simultaneously concrete and factualist, but, paradoxically, also 'unrealistic' and 'fantastic'. 'Looking at them', *Vogue*'s English edition commented, in 1925 upon the Rayograph, 'you are transported out of this sordid world where pipes are for smoking, and bells for ringing, into a fantastic region like that of our unconscious. . . where nothing has any meaning except as the decoration of a dream.[23]

By the close of the 'twenties the range of Modernist photographic techniques, Rayographs, multiple exposures, negative printing and solarization had been transmitted to London; partly through the channel of influential fashion and avant-garde magazines (*Vogue*, *Vanity Fair*, *Transition*, and *Close-Up*) and partly through the activities of the American expatriate contingent. Moffat's partner, Olivia Wyndham, established her own studio about 1928, employing Barbara Ker-Seymer as an assistant, who within two years began negative print portraits – as in *Nancy Cunard* (1930) – working with the British Surrealist painter John Banting, (another of Man Ray's friends). The portrait of *Nancy Cunard* that was one result of Ker-Seymer and Banting's collaboration, was greeted by Oswell Blakeston in terms that were reminiscent of Coburn's rhetoric when he commented, 'A mystical light of purity floods the model and the background'.[24]

It was significant that this area of experimentation was being developed by painter-photographers (both Moffat and Bruguière eventually turned to full time painting) and was directed towards a restricted, avant-garde public – Blakeston's own Rayograph experiments appeared in the small circulation cinema magazine *Close-Up*,[25] and Bruguière's in *Transition*. By the late 'twenties there was a strong climate of innovation in London that was in distinct contrast to the earlier part of the decade. It was being promoted by members of two major, avant-garde coteries – the circle of Moffat, Wyndham, Banting, Cunard, Man Ray and Ker-Seymer and that around Blakeston, Sieveking, McKnight Kauffer, Nash and Bruguière.

Francis Bruguière, who settled in London in 1928, extended Coburn and Moffat's experiments with light. He also worked on film projects, illustrated photo-books, took

Cut Paper Abstraction 1929
Francis Bruguière

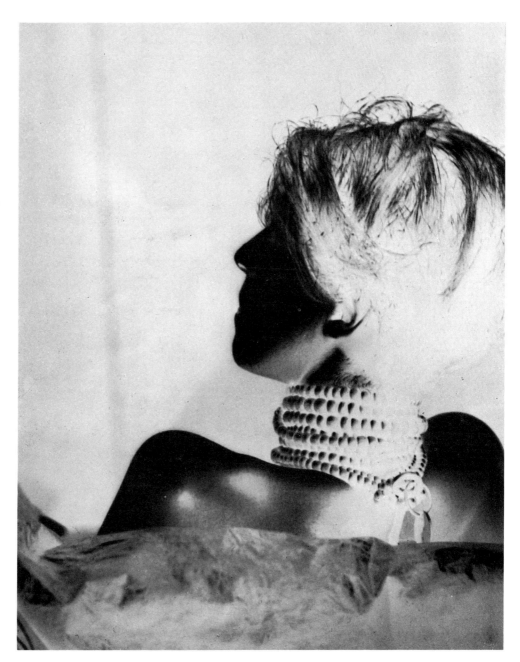

Nancy Cunard 1930
Barbara Ker-Seymer

Documentary photographs, and, in the corporate sphere, worked on publicity for private and government agencies in the period '1928 to 1939. His *Design in Abstract Forms of Light* (circa 1925–27) is typical of the purist work that Beaton was impressed by at the end of the 'twenties. To Beaton, Bruguière 'created an abstract world, which had for me a similarity with the Russian Ballet... a marriage of the camera and the essence of light....'[26]

Just as Man Ray and Moffat had isolated light as the primary signifying element in photography, by virtue of the camera-less and lens-less Rayographs, so Bruguière, another painter-photographer, also gave precedence to light:... '(his) designs are designs in light'.[22] The American designer and pioneer of streamlining, Bruguière's friend Norman Bel Geddes, wrote, 'He has not photographed an object that is beautifully lit and given it an atmospheric sentimental quality, but he has made light itself, a form'.[28] And, like the Rayograph format, Bruguière's *Abstract Forms of Light* series were direct, without retouching. 'Straight' and abstract photography were brought together in a streamlined form of light, an image of efficient Modernism. In 1933 Bruguière justified his multiple exposure photographs that had been exhibited at the Warren Gallery in 1929, 1931, and 1933, in terms of technocratic efficiency. 'This is the get-the-idea-at-a-glance-age... the elimination of "frills" has for some years been steadily taking place in other professions and industries. It is time for photography also to seek a new expression'.[29]

The abstract, experimentalist interests of Bruguière have largely obscured an important side to his career – his concern with documentary and reportage. In Berlin, in 1927, he became great friends with Kurt Hubschmann, later Kurt Hutton, of *Picture Post*. When they met, Hubschmann was just entering photo-reportage, but their interests kept them in contact throughout the 'thirties when Hubschmann came to Britain, and through the subsequent growth in photo-reportage magazines. Bruguière's interest was a practical one – his photograph of the Graf Zeppelin over London appeared in the photo-magazine *The Graphic* in 1931[30] and he began to take reportage photographs – one of *Lloyd George* (circa 1931) being a good example of the new, 'candid', factualist genre that was being pioneered in *The Graphic* by another German photo-reporter, Erich Salomon.

For Hoppé in 1919, New York was a New Jerusalem, a city of opportunity and modern architecture; when Bruguière returned there in 1932 he made a documentary series of the city during the Depression, photographing the skyscrapers, while writing an ironic commentary on the dereliction he saw about him. 'Isn't this the city Russia dreams about? Garbage cans taking wing with escaping paper filth and kids playing among the tissues of smells'.[31, 32] Yet this bitter documentary did not appear in the context of a popular photo-magazine but in the small circulation *Close-Up*.

Studio portraiture was one of the main institutional forms of photography in the period, with its West End practitioners interlocked with the customs surrounding high Society and its satellite worlds of stage and café culture. But portraiture, especially for women, formed a career structure which offered upward mobility. The two leading women studio portraitists, Dorothy Wilding and Madame Yevonde, were explicit on this point. The latter had been a

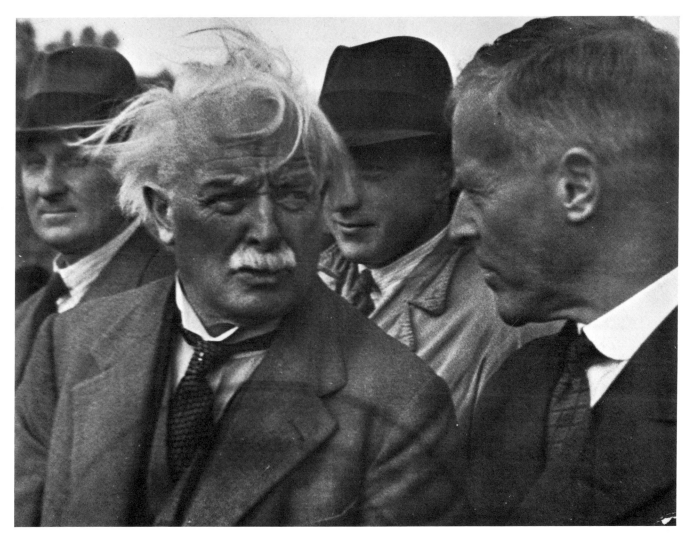

Lloyd George circa 1931
Francis Bruguière

Suffragette before the Great War and looked to photography as a means of emancipation, when she 'took up photography with the definite purpose of making myself independent'.[33] As the auxiliaries of high Society, the West End portraitists tried to efface their 'trade' status, and their memoirs are pre-occupied with the prestige that accrued through noble or royal patronage, thus redeeming their commercial character.

However, the portrait profession as a whole, despite a temporary upturn during the late 'twenties, was in a state of absolute decline. The factor which had brought this about was the

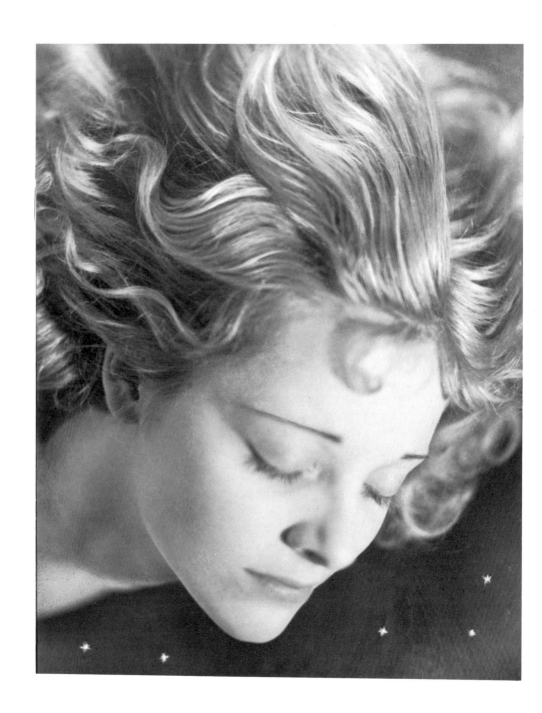

The Lost Pleiad 1934
Howard Coster

superseding of the individual studio with its manager and often large staff, by the mass produced portraiture which department stores began to offer. This occurred through the development of new, automatic photographic techniques, first with the Photomaton in 1928,[34] (which delivered eight small photographs in three minutes) and then, more decisively, the Polyfoto system (forty-eight negatives for 2/6d) in 1933,[35] which swamped the orthodox studio portraitists market.

From the outset, Polyfoto revolutionised portraiture and *The British Journal of Photography* warned its readers in the profession: 'there has arrived a system of portrait photography which challenges time honoured methods. . .the outfit may be put in premises of very limited size and the business thus planted down in the heart of a shopping quarter'.[36] The threat of this kind of competition was reflected in a lecture given by Madame Yevonde in May 1936, tellingly called, *The Future of Portraiture – If Any*.[37] Her tactic was to meet the challenge of 'store' portraiture through re-emphasising the role of the artist-photographer who could outdo such automation through pursuing forms and schemas from painting that could not be stereotyped by industrialised means.

Of all these technical advances the British Vivex Colour process seemed, around 1934–35, to be one of the most important steps in the formation of the mass media, along with the emerging forms of television, neon advertising and commercial radio.[38] In spite of all that, the prophesied leap forward, especially of magazines, into colour did not take place; its full development was postponed, to some extent by the restrictions of the Second World War, until the late 'forties and 'fifties. This was despite the introduction to Britain of Kodachrome in the late 'thirties and its consequent permeation, especially into fashion photography, (with Norman Parkinson's first colour work appearing in *Harper's Bazaar* in May 1938).[39]

Madame Yevonde was one of those practitioners who foretold the forthcoming supremacy of colour photography, arguing her case from the growing number of Technicolor cinema films arriving from America.[40] And, although she pointed to its dominant place in future mass-visual forms, she decided to make of it in the meantime, an exclusive fantastic form of photography, an object of limited circulation and high prestige. 'The colour photograph, an entirely new medium, must be more nearly related to the portrait painted by an imaginative artist, than to its blood relation, the passport photograph. . . . The colour photograph was to be something precious not to be doled out in dozens. . . .'[41] This was the rationale for her *Goddesses and Others* series in 1935 – an attempt simultaneously to cope with and exploit technical change, to maintain her end of a deluxe market, and to channel the new vanguard style of Surrealist painting into the depiction of Society (where, in Yevonde's portraits like *Mrs Michael Balcon, as Minerva*, (1935), the charade-like picture, looked back to a mock-classical, Victorian mode.)

Coster was an established and conservative portraitist, but he praised and recommended Man Ray's *Photographs 1920–34* that had been published in 1934. Innovation was now necessary in portraiture – for, just as Yevonde advised 'be original or die',[42] Coster stressed, 'above all, be original at all costs'.[43] Experimentation to save one's livelihood seemed vital and

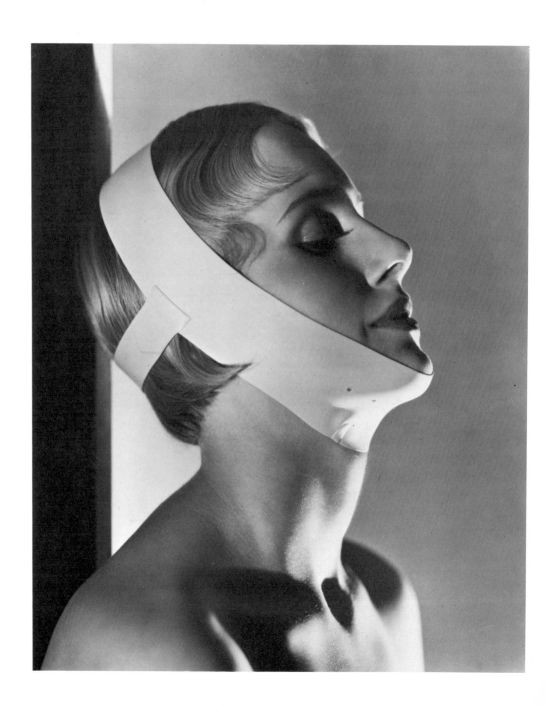

*Sylvia Ironside's Chin
Reducing Strap* 1933
Shaw Wildman

Coster made a skillful pastiche of a vertiginous Man Ray female head in *The Lost Pleiad* (1934).[44] This photograph joined a growing iconography of sub-Surrealist mock-classical, elevated, dreaming women's heads that were added to the visual imagination of the early and middle 'thirties, often for commodity advertising purposes. Photographers like Rosalind Maingot, whose flying head *Chrysalis* (1933), appeared in the London Salon in September 1933,[45] and Shaw Wildman, in a portrait of Natalie, Lance Sieveking's wife, used in an advertisement for *Sylvia Ironside's Reducing Chin Strap* (1933),[46] deployed this type-image as well.

Howard Coster was, after all, an unlikely convert to the fantastic imagery of Surrealism. His portraiture had been austere and patriarchal in the late 'twenties, after he had opened his studio in 1926 under the sign 'Photographer of Men'. Indeed his conservatism had been seen as his strong point by commentators: 'He is the modernist who stayed at home'[47] – and he concentrated upon portraying figures of authority in public life, like his monumental *G K Chesterton* (1926), or exemplars of masculine prowess; air aces, industrial magnates and sports champions, in portraits that positioned the viewer as a hero-worshipper. In his portraits Coster reduced the undertones of flamboyance in his sitters but it was this very trait which Peter Rose-Pulham, who worked in his studio in the latter part of 1932, developed to an extreme. His 1938 portraits of Parisian painters, especially that of *Christian Bérard* (1938), used the same romantic, monumental silhouette as Coster's *G K Chesterton*, of twelve years before.

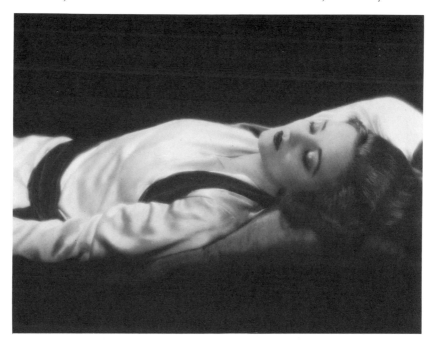

Tallulah Bankhead 1928
Paul Tanqueray

Clearly portraiture from the late 'twenties onwards was undergoing transformation, both functionally and stylistically. On occasions this was marked by an open assertion of mass media forms. For example film, especially cinema lighting and the conventions of publicity stills, were a major influence on Paul Tanqueray, who posed *Anton Dolin* (1928) in a re-creation of the prone robot of Fritz Lang's UFA epic *Metropolis*. Tanqueray was mainly intent upon using the immaculate Hollywood stills of star actors and actresses as a means of publicising London stage and Society personalities through the 'Society-glossies', chiefly the *Sketch* and *Bystander* illustrated magazines. It was in this way that *Ivor Novello* (1928) became Americanised in Tanqueray's portrayal. But in *Tallulah Bankhead* (1928), Tanqueray had found an adequate living symbol – a star – an American actress who had become part of London's high bohemia. Tanqueray's portrait of her reclining constitutes a great homage to the Hollywood still photographers.

While photographers like Madame Yevonde, Cecil Beaton and Angus McBean looked to a closed, directorial style of high artifice,[48] Barbara Ker-Seymer used an altogether more relaxed Realist style, derived from news-reportage and applied to the depiction of Mayfair personalities. Just after her negative print *Nancy Cunard*, she began work as a gossip columnist photo-reporter for *Harper's Bazaar*: the demands of the magazine format – for direct Society reportage rather than an experimentalist aesthetic – encouraged her to adopt a new Realism. Instead of theatricalised 'camera studies', Ker-Seymer's portraits were 'straight', and described by the magazine as 'snapped informally',[49] that is, they were meant to be read in relation to the category of candid camera reportage – the genre which Erich Salomon had pioneered in *The Graphic* magazine in 1929.

With photographs of Royalty, the nobility, politicians and clergy the candid Society portrait, for example, 'Unsuspected Moments With Prince George'[50] opened up previously restricted social settings. It was contingent upon another set of technical developments which disrupted British photography around 1930. In this case it was the arrival of small, portable German cameras – Ermanox, Leica and Rolleiflex. Ker-Seymer realised that her half-plate Soho camera with its tripod was increasingly inappropriate for informal portraits and she eventually purchased a Rolleiflex for her *Harper's Bazaar* assignments. But it was through the intervention of her colleague Humphrey Spender, that the social range of subjects for 'straight' candid portraiture was conspicuously widened to include all classes in Britain, when he began work with a Leica as 'Lensman' of the *Daily Mirror* at the end of 1934. It was in that year that candid Documentary reportage emerged, a genre supported by the *Daily Mirror*, *Daily Herald* and the new photo-magazines, *Weekly Illustrated* (and later *Illustrated* and *Picture Post* in 1938).[51] From about 1934 the style of Documentary reportage began to invade all the photographic genres that had previously incorporated naturalism.

Documentary reportage also permeated and transformed the photographic travel book, (a form which Hoppé was undisputed master of), to such an extent that *Cecil Beaton's New York*, published in 1938, contained some extraordinary exercises in this style. Some by Beaton, like his *Hat Check Girl* (1937),[52] were hybrid fashion/documentary pictures and Ben Shahn's Social

Anton Dolin 1927
Paul Tanqueray

Realist photographs of New York streets were also included, introducing the American FSA documentarists to Britain. Beaton was congratulated over the book by Raymond Mortimer: 'There has never been vivider reporting'.[53] It was an indication of the ascendency of the photo-reporter as a serviceable role for the professional photographer, it was, additionally a paradox that Beaton, of all photographers, had assumed this role by 1937.

For, 'Beaton is not, strictly speaking, a maker of documents:...he is, pre-eminently, an "arranger"...',[54] so Paul Nash had written in 1931. He was making an elementary division in British photography between 'documenters' and 'arrangers', a division which corresponds to some extent with the division during the period between 'straight' factualism and controlled directorial methods. Beaton's place in such a scheme is not as simple to locate as it might first seem. Osbert Sitwell, writing on the occasion of Beaton's first exhibition in 1927, tried to expose the complexity of the photographs, first drawing attention to Beaton's anti-Pictorialist purism, 'The peculiar excellence of Mr Beaton's photographs is that they are so photographic. He never tries to make them into pictures or statues and there is no haze, no scotch mist

Hat Check Girl 1937
Cecil Beaton

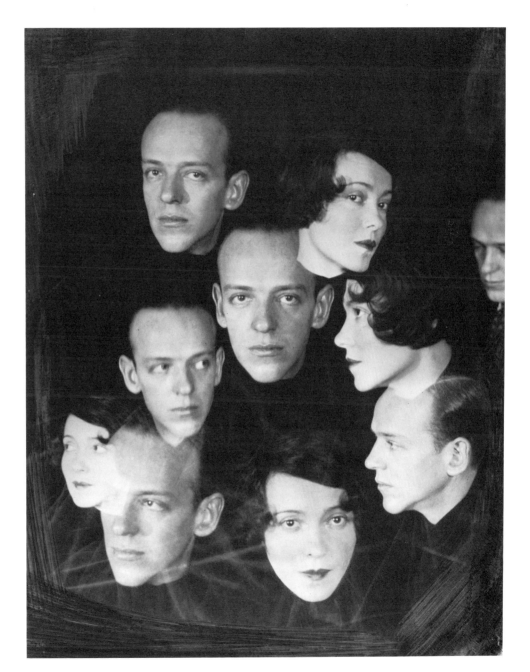

Fred & Adèle Astaire circa 1930
Cecil Beaton

through which the familiar features can loose themselves, while the flattery is of a much more subtle, because realistic, kind'.[55] Beaton, on the basis of the exhibition, struck critics as an anti-Pictorialist prodigy, a Modernist photographer who did not retouch or manipulate, essentially a 'straight' photographer. 'Instead of "monkeying with the machine" as photographers are apt to do, or checking the natural behaviour of chemicals in development and printing Mr Beaton spends all his ingenuity on the material with which he feeds the camera'.[56]

Arrangement, ingenuity, novelty, and conjuring[57] were of course crucial to this aesthetic. The world of charades and aristocratic tableaux lay behind the *Portrait of Edith Sitwell* (1927). This photograph was the sensation of the 1927 exhibition:- 'the most repellent of all these eccentricities is the "portrait" in which the fragile figure of Miss Edith Sitwell is shown'.[58] The portraits he showed depended upon their decor, 'arrangement' and their choreography for their success. Related to this, was Beaton's involvement, in early 1927, with certain charity matinées in which debutantes and society personalities would participate in theatrical tableaux. For these Beaton was director, costume designer and photographer. He exhibited some of these designs – for Olga Lynn's 'Great Lovers of Romance' – at his Cooling Galleries show later in the year.[59] Such masque, charade or pageant occasions were very important for other portraitists as well; there they were offered a fantastic, para-theatre of high Society.

In 1927 Beaton stood outside commercial portraiture, adopting a dandy pose, by carrying that repression of 'trade' status found in portrait photography to its logical conclusion. Thus at the time of the Cooling exhibition he resolutely refused to accept commissions; a denial of the principle function of such an exhibition within the generally convened practises amongst professional photographers. His dandy pose was that of the artist-photographer amateur, 'we were warned that we must not regard it as a commercial enterprise'[60] wrote a reporter visiting the exhibition. Beaton's amateurism extended to his equipment, like Paul Nash and like a mass of amateurs he used a cheap 'snap-shot' camera, a Kodak folding pocket camera. This led to another dandyish paradox, 'The exquisite photographs he produces are the fruit of the simplest of all photographic machines'.[61]

And yet he understood the opportunities for public attention and fame afforded by photo-mechanical reproduction. He had, in the course of 1927, taken part in what amounted to a publicity campaign for the Sitwells, mounted through placing photographs like the recumbent portrait of *Edith Sitwell* in magazines like *The Sketch* and *Eve*.[62] He had spent his childhood and adolescence fascinated by the trappings of theatrical fame, seen through the half-tone photographic magazines of the period just before the Great War and immediately after. But as he manipulated the new gossip columnists[63] of the daily press in the late 'twenties, his imagination was fixed, (and arguably remained fixed throughout much of his entire career), upon that lost world before the Great War. Beaton venerated that epitome of the pre-Great War gentlemen photographers, Baron de Meyer, who had participated in Edwardian high Society as well as recorded it. Beaton's fixation upon Neo-Victorian and Neo-Edwardian styles and his fantasised attempt to reconstitute that lost world was in fact, part of a more general cultural movement in Britain. It was an attempt to bypass the trauma of the Great

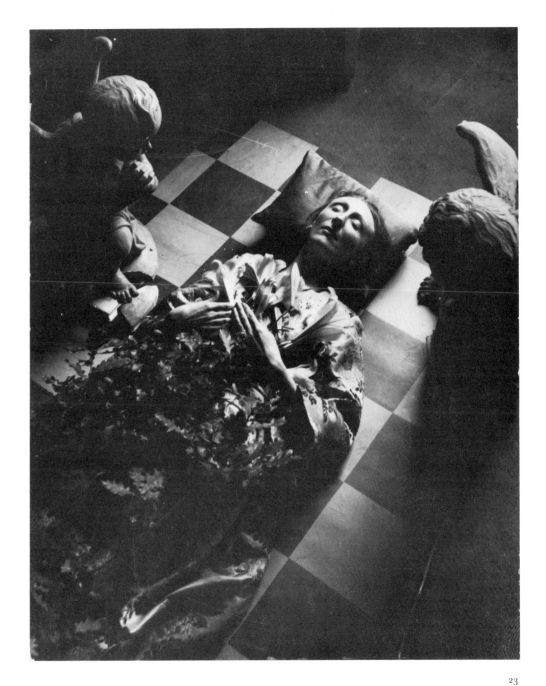

Portrait of Edith Sitwell 1937
Cecil Beaton

War and settle upon a pre-war utopia. E J Hobsbawm has recorded the political aspect of this movement: 'After 1919 Britain appeared to recover – and a heroic attempt was made by her governments to recreate the conditions of 1913 and thus to restore that lost paradise...the slump of 1929 destroyed the illusion of a return to the *belle epoque* before 1913'.[64]

While Ker-Seymer saw her realist photography in terms of the post-war, post-slump informalism, Beaton became part of a counter-thrust in the arts, which coalesced, in the late 'twenties, around the Neo-Romantic painters. This movement was often articulated at an aristocratic, mock-epic level, as can be seen for example, in Rex Whistler's paintings. The orientation was towards historical revivalism, surface exaggeration, hyper-stylisation and what we might term a *camp* sensibility. As Susan Sontag pointed out, camp has a definite function, it is 'the answer to the problem; how to be a dandy in the age of mass culture'.[65] This was, in essence, the problem that Beaton addressed himself to, especially after he was lodged within the corporate structures of Condé Nast's magazine empire following his visit to America, late in 1929.

The post World War I period seemed to become more mechanised and corporate than ever before, Mayfair could be seen to be 'changing into a Robot Hive'.[66] Beaton's response was a dandified one; 'to decorate a machine with dog roses'.[67] Through his revivalist strategies of whimsical Neo-Victorianism, the modern forces of the profane world could be imagined held at bay. Of course, they were not: he was enmeshed in them and had been since about 1929, when Beaton became a photo-journalist for one of the largest multi-national magazine publishing corporations. The term photo-journalist has been generally reserved to describe reportage photographers of the news magazines and daily press. But Beaton was from 1929 onwards, a fashion and society photo-journalist, primarily an agent of *Vogue*. A new system for the patronage and organisation of professional photographers seemed to be coming into play as the 'thirties began, and by the mid-'thirties, many of the independent photographers of the late 'twenties were working within the framework of corporate patronage; Curtis Moffat for Shell Mex; Maurice Beck for Shell Mex and BP; Barbara Ker-Seymer for *Harper's Bazaar* and Howard Coster for ICI. Even Madame Yevonde was commissioned for the American business magazine *Fortune* in 1937. In all this, Beaton's assimilation into *Vogue* was a turning point.

The *laissez-faire* epoch appeared at an end. Bruguière, for one, saw a planned, co-ordinated future for the photographer within the structures of large scale commercial photography, with co-operation between designers and photographers.

The emerging outlines of this corporate role for photography could be discerned in the new exhibition venues for photography which began to appear from about 1930. The salons of the 'thirties which exhibited advanced photography in London were not the same institutions as ten or twenty years before, such as the Royal Photographic Society or the London Salon of Photography. Instead they were the Professional Photographers Association Exhibition of Industrial Photography, or at Crawford's Gallery in an advertising agency, or at Lund Humphries Gallery at the printing firm's premises. It was in the latter's exhibition space that Bruguière showed his collaborative work with the designer Edward McKnight Kauffer in

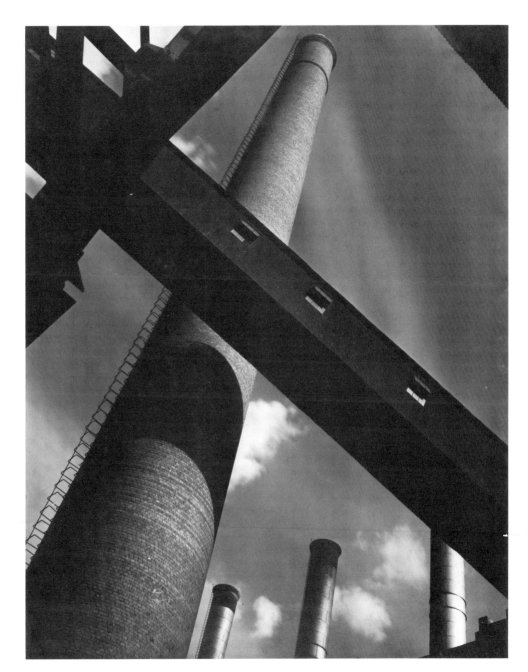

Chimney circa 1932
Noel Griggs

1933, and Man Ray's first London exhibition was held at the same gallery in November 1934.[69] Another important exhibition venue, the Camera Club, was revived about 1929 under the direction of the leading London advertising chief, Sir William Crawford, and it soon became a key location for the display of continental Modernist photography. Through exhibition centres like the Camera Club, the work of American, French, German and Soviet exponents of the new style – Sheeler, Hoyningen-Huene, Burchartz and El Lissitzky – became familiar. The established institutions, particularly the Royal Photographic Society, tried to adjust to the challenge from commercial bodies which were enforcing a wider acceptance, by their preference for the new 'straight' photography within advertising. Thus, 'The New Objectiveness' was the subject of discussions at the RPS in January 1930;[70] as was 'The New Photography' in February 1932;[71] eventually the debate led to a large symposium being held on commercial and other aspects of 'Modern Photography',[72] in January 1933. It was the ratification of the new style which was at issue and the RPS was forced through these events, to acknowledge that 'photography was passing through a revolution'.[73] Pictorialist photography was finally displaced by the weight of commercial pressures and the mega-visual sector of publicity that existed outside the RPS and the moribund salons. In the light of this displacement, recent history had to be revised, Ward Muir's and Strand's 'straight' work was, with the advent of the New Objectivity and dynamic assymetric compositions, revalued as pioneering efforts in this field.[74]

THE PREDOMINANCE OF
ADVERTISING
PHOTOGRAPHY

Once more it was American attitudes to business organisation, this time in the advertising industry that were the determining factors. From the middle 'twenties, especially during the economic boom of 1926–9, American advertising agencies opened branches in London. J Walter Thompson was the largest and it was here that Shaw Wildman, a journalist, learned layout and design skills before becoming a commercial photographer. His attitude exemplified the new commodity realist approach, 'I would attempt to make a picture out of anything from a society beauty to a bunch of sausages!'[75] W D Hoedt, the Philadelphia publicists, opened a London photographic studio about 1927, with the New York photographer Frances Feist, as Manager. It was here that John Havinden (one of those who argued the validity of advertising photography before the RPS in 1933[76]) trained in 1929–30.

While E O Hoppé could see the opportunities in the field of advertising photography he was nevertheless not as capable of learning Modernist commercial advertising skills as Coster or the much younger photographers of the John Havinden or Noel Griggs generation. This was evident in his Pictorialistic vision of industry – *The Romance of Steel* (1920s). Havinden was introduced to the commercial work of Steichen and Sheeler through the American magazines, *Vanity Fair* and *Transition*. Sheeler's epic industrial photography, reproduced in *Transition* in 1929,[77] of the Detroit Ford Plant with repeated, crossed, diagonal lines were as influential for him as they were for Noel Griggs when he photographed *Chimneys* (circa 1932). Here was a new guiding myth and a new iconography for photography, as *Transition* noted, in Eugene Jolas' title for Sheeler's work – 'Industrial Mythos'.[78]

Hand Drill circa 1933
Walter Nurnberg

COMMERCIAL
PHOTOGRAPHY: THE GOLD
RUSH

Commercial and industrial photography expanded enormously between 1930 to 1935 during a fluid period of rapid transits by photographers between rival commercial studios and the establishment of new studios. In the words of Walter Nurnberg, who arrived in London in 1934 from Berlin with a first-hand practical knowledge of Neue Sachlichkeit photography; it was 'a gold rush... Industry and commerce offering better remuneration than the portrait client, exerted a great attraction and promoted a general stampede'.[79] In this stampede a new kind of photographer came to the fore, one to whom the corporate world was definitely congenial. John Somerset Murray, for example, was inclined towards electrical engineering, Maurice Beck had originally trained and worked as an engineer, and Walter Nurnberg had begun as a business consultant. Their manifest reluctance to 'decorate a machine with dog roses,'[80] was symbolised by Nurnberg's close-up photograph *Hand Drill* (circa 1933), a harsh, cold product of the New Objectivity style, utterly unretouched and precisely 'straight', at ease in the corporate world.

FASHION PHOTOGRAPHY IN
LONDON

Between them, the American publishing empires of Condé Nast, whose *Vogue* began its British publication at the beginning of the period in 1916, and William Randolph Hearst's *Harper's Bazaar*, which was established in London in 1929, effectively determined the development of British fashion photography. While *Vogue* had Cecil Beaton, *Harper's Bazaar* fostered, through its London art editor's high degree of autonomy from New York, two of the most innovative and distinguished British fashion photographers of the thirties, Norman Parkinson and Peter Rose-Pulham.

The art editor who was A Y McPeake also encouraged Shaw Wildman, who emerged in 1932 with an immaculate, 'frigidaire'[81] style, which he used to present Matita sports clothes from this time until the mid 'thirties. His development of the Matita series over two years reveals one of the main directions in fashion photography in the period. Shaw Wildman began with images openly drawn from high-art sources: *Matita (Mrs Ronald Balfour with Dogs)* (1932)[82] appears to have been based upon Charles Furse's Impressionist painting *Diana of the Uplands* (1903), and Wildman's 'frigidaire' style also owed much to Tissot's icy paintings of London Society beauties in the 1870's. But in 1933 and 1934 Wildman went to racetracks and aerodromes to photograph the models talking to mechanics and drivers, producing a movement towards reportage fashion photography in, for example, *Burberry at Brooklands* (1933), [83] that anticipated the 'Action Realist' style of fashion photography developed by Munkacsi, Jean Moral and Norman Parkinson in the mid 'thirties for *Harper's Bazaar*. It was in 1933, at the London office of *Harper's Bazaar*, that McPeake received Jean Moral's realistic street fashion photographs and realised that the Baron de Meyer's static, hieratic style had been superseded: 'The Baron was finished'.[84]

Burberry at Brooklands 1933
Shaw Wildman

Matita
(Mrs Ronald Balfour
with dogs) 1932
Shaw Wildman

This was Parkinson's point of entry, placing models in London parks and streets, often taking low angle viewpoints picturing the free, active models in the middle ground behind other silhouetted, out of focus foreground figures. All of them belonged to the actual environment, a Guardsman on duty at Buckingham Palace,[86] or a newspaper seller, in his *News in London* (1938).[87] For, on first sight, the photograph *News in London* is not obviously a fashion picture. One of the classic devices of Realist news and social reportage had been appropriated by Parkinson; the notion of seeing past or through spectators or participants, onto an event. In *News in London* we look past, or rather with the newspaper man, we are introduced into the frame of the action through a delegated spectator, a kind of indirect directness which was very similar to Humphrey Spender's recurring compositional ploy in his street pictures for Mass Observation of spying past a figure, a device evident in his *St James Park* (1938).

While Parkinson had transposed candid, Documentary Realism, into fashion, Peter Rose Pulham, with his work for *Harper's Bazaar* between 1934 and 1938, made a massive restatement of Romantic arrangement and artifice. Like Parkinson, Pulham made his photographs full of action, but he placed the protagonists in dark bizarre, artificial settings where there is movement and gesture. The overall effect appeared baroque and extravagant, far exceeding a naturalistic representation. Along with Humphrey Spender, William Edmiston and Edwin Smith, Peter Rose Pulham had initially trained as an architect and like them was part of a definite wave of disenchanted reaction against the modernist international style in architecture, an anti-modernist perception that was also shared in the early 'thirties by John Betjeman. At this time a reinstatement of pre-Twentieth century ornament became important to them, just as it had been a few years earlier to Cecil Beaton. Yet all carried through their decorative programme on the plane of photography rather than architecture.

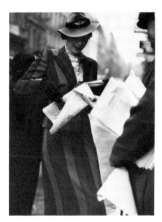

News in London 1938
Norman Parkinson

St James Park 1938
Humphrey Spender
(left)

Skating Scene circa 1937
Peter Rose Pulham

A protégé of Beaton's, Rose Pulham adopted his rôle of dandy in the presence of mass culture; but with tragic rather than mock or comic overtones. His photographs became cyphers for melancholia in sombre, lightning flash fashion scenes, as in *Fashion Study* (circa 1935), or locations for elegaic dramas, nocturnal skating, as in his *Six Multiple Exposures. Skating Scene* (circa 1937). Venetian masquerades and erotic reveries in closed chambers acted as supports for fashion pictures which appeared to record illicit scenes. He accompanied his *Harper's Bazaar* photographs with prose-poem texts which underlined his orientation towards 'elegaic memory'[88]. One text explored his Neo-Romantic exhaustion: 'The ghost of a Waltz of 1880 is dust whirling in front of the tarnished ballroom mirrors in an empty house; white shrouds cover the chandeliers. . . we have just been through a period in which the speed and efficiency of machinery seemed to us exotic in itself. . .'.[89] But now, following Betjeman's notice of the 'Death of Modernism',[90] – 'romanticism with a discord of sadness, malice or brutality has replaced the desire for modern classicism'.[91]

SURREALIST PORTRAITURE
AND STILL LIFE

Rose Pulham's swing into the past was supported by the rise of a comprehensive Neo-Romantic and Surrealist visual imagination in painting. Bérard, Cocteau, Berman and Dali became his colleagues once he settled as a painter in Paris in 1938 and his portraits of them mark virtually his last work as a professional photographer.[92] By 1935–6 Surrealist painting and photography was exerting a formidable influence upon British photography. Angus McBean, a young theatrical and portrait photographer had been impressed with Dali's paintings which he had seen at the International Surrealist exhibition in the summer of 1936.

In the magazine *The Sketch*, from December 1937, McBean arranged actresses and celebrities before an illusionistic Dali-esque backdrop painted by the British Surrealist Roy Hobdell. It was in this series that he photographed *Frances Day* (1938): a West End musical star before this backdrop depicting twilight and a foreshore at low tide (a favoured image for Dali and Tanguy) which, bizarre as it may appear, in the context of Coster, Rose Pulham and Beaton's arrangements and histrionics, it fell easily into the pattern of British portraiture of the period.

The genre of still-life also lay open to Surrealist initiatives: it was by virtue of his commercial still life photographs for Victor Steibel that Rose Pulham had originally come to prominence,[93] and the paintings of De Chirico and Magritte lay behind the classicising photographs of Winifred Casson and Somerset Murray in 1935. Francis Bruguière and Curtis Moffat separately tried to blur the boundary between still life painting and still life photography around 1933–5.

SURREALISM AND REALISM –
THE SPLIT

The frozen fixity of Surrealist illusionist painting made it a style that was particularly susceptible to photographic mimicry. Before taking up photography and going into partnership with Humphrey Spender, the architect William Edmiston had written on the Surrealists and De Chirico's painting for *Harper's Bazaar*.[94] By the mid-'thirties Edmiston was in open opposition to the rise of Documentary Realism. Splitting from Humphrey Spender, he pointed out 'Realistic photography? My answer is; not angle photography, nor yet montage. . . but Super-Realistic treatments. . . that are made more than Realistic with frankly

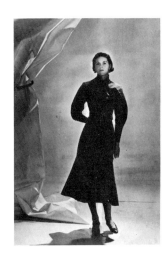

Fashion Study circa 1936
Peter Rose Pulham

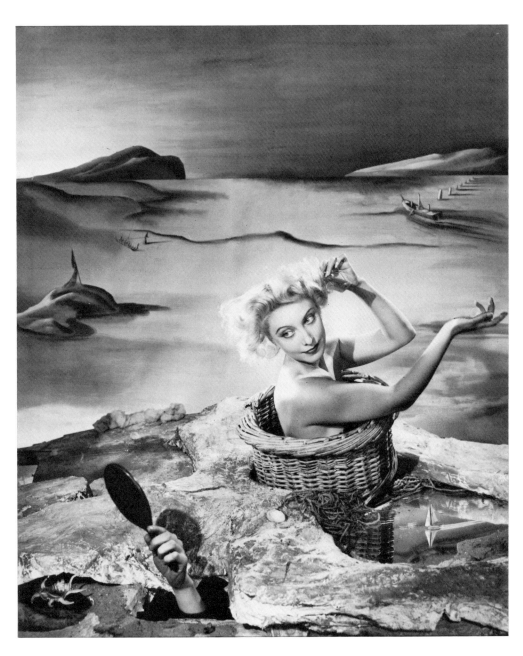

Frances Day 1938
Angus McBean

unreal lighting'.[95] It was in fashion photography, obviously with Rose Pulham in mind, that he found his vindication; and at the end of 1934 he set to work on Surrealist advertising photographs for the interior decorating firm *Bird Iles*, while in contrast, his partner entered the *Daily Mirror* as roving photo-reporter, 'Lensman'.

HUMPHREY JENNINGS

Here was a symbolic division between Realism and Surrealism, but some photographers, notably Humphrey Jennings, Bill Brandt and Edwin Smith managed to reconcile these divergent tendencies in the second half of the 'thirties. Jennings for example was primarily a Surrealist painter, but he was also a Documentary film maker for the GPO. As befitted one of the co-founder of the social survey Mass Observation, he was aware of contemporary American FSA Documentary photography, especially Walker Evans' pictures,[96] as well as Man Ray's Dada and Surrealist photography. It may be that Man Ray's study of ashes and rubbish, *Transatlantique* (1920) was a model for Jenning's photograph of an old newspaper on a deserted floor, *Daily Worker* (1937-8). The latter was a Surrealist *objet trouvé*, and yet still a document redolent of social dereliction, an ironic commentary on hopes of poltical radicalism.

A CATALOGUE OF SOCIETY:
BILL BRANDT

Emphasis lay upon the ensemble in Social Realist photography, it was to be the totality of Humphrey Spender's Mass Observation pictures that, when organised and concerted would it was believed, fully document the culture of Bolton and Blackpool. The project of the new Social Realist documentarians was enormous in scale; a cross section inventory of British, especially northern industrial working class culture. It was an anthropological adventure (Raymond Mortimer, a later enthusiast for Cecil Beaton's urban Documentary style, in his introduction to *The English At Home*, likened Brandt to a anthropologist, while Mass

Daily Worker 1937–8
Humphrey Jennings

*East End Girl Dancing
the Lambeth Walk* 1938
Bill Brandt

Observation was based squarely upon anthropological methods).[97] The Left-Liberal point of view promoted a belief in the direct power of the 'straight' photograph: 'These are photographs not of actors in realistic stage-sets, but people as they are, in their real and inescapable surroundings. Is there any English man or woman who can look at these without a profound feeling of shame?'[98] Mortimer wrote of Brandt's pictures. But the real articulation of this message came about through the contrasts, between different classes which Brandt laid out when he composed the book. The cover itself announced this form of juxaposition – on the front, a high born group of spectators in dress suits watch the Derby, while on the back, working class children in well worn clothes cluster around their mother. Other Social Realist photographers worked along similar lines by constructing this kind of contrast, for example, Edith Tudor Hart, whose work was featured in this way in *Lilliput* used photomontage for agitational political ends, through the Workers Camera Club.

Brandt had taken up photography in 1927–8, he had inspected the showcases of the Bond Street portraitists and found them 'too old-fashioned'[99] but he relied upon a 'straight' Hoppé-esque means of photographing picturesque street types at the Caledonian market in 1928.[100] But the following year he assisted Man Ray in Paris, and it was by his contacts there, with the work of Brassai and Kertész, that he was able to remake his earlier documentary photography. Spender was similarly transformed by examining photo-reportage during his stays in Germany around 1930.

SURREALIST REALISM

The form of social Documentary was being reinvented and for Brandt the aesthetic of 'Surrealist Realism'[101] became paramount in the 'thirties. It was Louis Aragon, one of Curtis Moffat's Paris circle, who had outlined this sensibility in his book *Paris Peasant* (1928). It was founded upon the wish to seek out an urban folkloristique culture, small businesses, old shops, alleys – environments and customs that were marginal to the modernist version of the metropolis and were rapidly disappearing. Here then was the subject matter of some of Atget's photographs, of whole sections of *The English at Home* and of much of Humphrey Spender's forays into Whitechapel,[102] photographing figures like *Street Organist in Pub Doorway* (1938). The response of the social documentarists was analogous, by their conservation of the past, to Beaton and Rose Pulham's romantic responses to the conditions of the time.

Indeed, in terms of iconography, the image of the dress shop mannequin was common to both Surrealist and Social Realist, and it was utilized by Brandt,[103] and by Edwin Smith in his, *Dover St. Court Hairdressers* (1935). Edwin Smith was familiar with Atget's photographs and in 1935 he photographed customised shop frontages, draper's dolls, ironmongers and fairground horses in an antiquarian manner, celebrating (again, like Beaton and Rose Pulham) Victorian and Edwardian decor; sometimes in the more decidedly populist context of the saloon bar.[104] He was helped by Oswell Blakeston and Paul Nash, who arranged a shortlived commission for Smith as a *Vogue* fashion photographer, and, more importantly, enabled him to have access to the facilities of Lund Humphries' photographic studio. Smith was a virtuoso photographer: a 'straight' Social Realist in *Miner at Ashington Colliery* (1936) and a lyric nature romanticist in his picture *Elm Trees* (1938). It was with photographs like this last, that he came closest to his

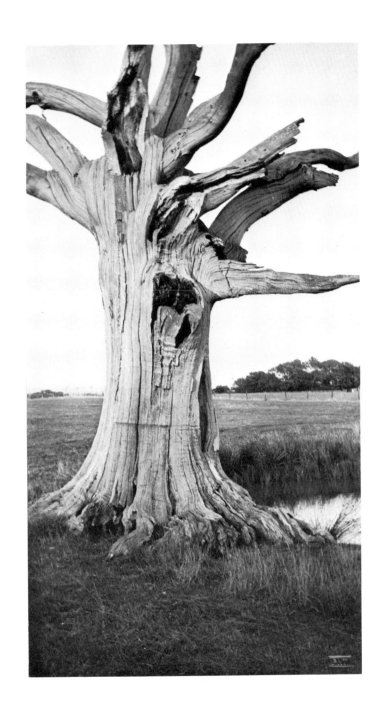

Dead Tree,
Romney Marsh circa 1932
Paul Nash

patron, Paul Nash.

Nash and others had drawn out an emphasis on the photograph as document at the beginning of the 'thirties. Brian Howard, a collaborator with Barbara Ker-Seymer, wrote; 'This emphasis on the purely documentary value of a photograph – its value as a map merely – is liable to make people underestimate its potentiality as a work of art... It will therefore be a great pity if this point of view comes to be aspersed.'[106] His anxieties were misplaced: by the close of the 'thirties the category of documentary had become triumphant and was a component in almost every genre and function of photography, in the Action Realism of Norman Parkinson; in the antiquarianism of Edwin Smith, in the urban-bizarre photographs of New York by Cecil Beaton, and in the Surrealist Realism of Bill Brandt.

Notes

1 Ward Muir 'Straight Prints from Straight Negatives' *Amateur Photographer and Photography* 13 August 1919 page 144

2 'Mr Muir's Propaganda' Imperial Dryplace Co, *Amateur Photographer and Photography* 20 February 1920 page iii

3 F C Tilney 'An Old War-Path' *British Journal of Photography* 30 January 1920 page 66

4 Ward Muir 'How the Camera Gave Me a New Eye' *Graphic* 17 April 1920 page 602

5 See *Camerawork* number 49/50 June 1917 page 21 and 23

6 'Portraits and Other Studies by a Group of Professional Photographers' *British Journal of Photography*, 9 July 1920 page 423

7 'Portraiture at the Salon' *British Journal of Photography* 17 September 1920 page 567

8 Dorothy Wilding *The Pursuit of Beauty* 1958 pages 17–18

9 Illustrated, *Photographic Journal of the RPS* September 1925

10 Characteristically, one of her best photographs is called 'Frieze'; illustrated 'What the Ladies Say' *Professional Photographer* 1924 page 268

11 'Little One Man Shows' *Amateur Photographer and Photography* 14 May 1924 page 467

12 ibid

13 See *Vogue* July 1930 page 37 for a very similar image to Lambert's *Girls Head*

14 In his lecture, 'Modern Methods of Portraiture', reported *British Journal of Photography* 30 April 1920 pages 267–70

15 *Camerawork* number 49/50 June 1917, page 9, 11, 13, 15 and 19. The elderly ladies depicted on page 9 and 15, were quite obviously prototypes for Hoppé who had ample opportunity to see the photographs during his many visits to New York immediately after the Great War

16 *Weekly Illustrated* 20 April 1935 page 28. I am grateful to Colin Osman for having drawn my attention to this feature

17 See, for example, Douglas Goldring *The Nineteen Twenties* 1945 page 51

18 *British Journal of Photography* 8 February 1924 page 3. 'The Discourse was in its very essence aetherial', commented the reporter, at a loss to describe the proceedings

19 See news cutting dated 8 July 1926, Moffat Cuttings Book, courtesy Mrs Catherine Moffat. 'Paintings with Light' was Man Ray's phrase, see Arturo Schwarz *Man Ray at the Rigour of Invention* 1977 page 236

20 ibid

21 see 'Studies in Black and White' *Vogue* late November 1925 page 76

22 Cecil Beaton *The Wandering Years* 1961 page 147

23 see note 21

24 Oswell Blakeston *Architectural Review* April 1932 page 157

25 eg *Designs in Light* were reproduced in *Close Up* November 1929 opposite stills from Grierson's first documentary, *Drifters*

26 Cecil Beaton *Photobiography* 1951 page 38

27 Mercurius 'Light' *Architectural Review* January 1930 pages 38–9

28 Norman Bel Geddes 'The Photography of Francis Bruguière' catalogue of The Art Center, New York, March/April 1927

29 Francis Bruguière 'Will this be the Photography of Tomorrow' *Photography* November 1933 page 6

30 'Looking Up. Effort and Achievement. A Special Study of the Graf Zeppelin passing over the girders and cranes...' *The Graphic* 22 September 1931

31 'Speaking Professionally' *Close-Up* April–July 1933

32 'With Eagar Fingers straining at the Stars' *Bystander* 18 January 1933 page 120

33 Madame Yevonde *In Camera* 1940 page 283

34 See 'Photomaton' *The Graphic* 25 February 1928 page 332, and *Brittania and Eve* June 1929 page 13

35 ''Polyfoto" – The New Portrait Photography', *British Journal of Photography* 21 July 1933 pages 421–2

36 ibid page 422

37 Madame Yevonde 'The Future of Portraiture – If Any' *British Journal of Photography* 29 May 1936 pages 34–7

38 *British Journal of Photography* 27 July 1934 page 451 and 11 September 1936

39 'For the South of England, France or Africa...' *Harper's Bazaar* May 1938 page 82

40 see note 37

41 see note 33 page 189

42 see note 37 page 35

43 Howard Coster *British Journal of Photography* 23 October 1936 page 681

44 Compare *The Lost Pleiad* with *Volto* circa 1930 reproduced in *Man Ray, L'Immagine Fotografica* Venice 1977 plate 97, and also see plate 101

45 reproduced *Bystander* 20 September 1933 page 518

46 *Sketch* 9 November 1932 page 264

47 Howard Wadman 'Howard Coster' *Commercial Art* June 1932 pages 242–3

48 For a discussion of this term see, A D Coleman 'The Directorial Style' *Artforum* September 1976

49 *Harper's Bazaar* April 1932 page 70

50 *Graphic* 4 May 1929

51 For a full account see Ian Jeffrey 'Feeling for the Past' *Thirties* Arts Council of Great Britain Catalogue 1979

52 Cecil Beaton *Cecil Beaton's New York* 1938 New York page 209

53 Raymond Mortimer to Cecil Beaton 25 October 1938

54 see Paul Nash 'Art & Photography' *The Listener* 18 November 1931, pages 868–9

55 Osbert Sitwell 'Appreciation' *Cecil Beaton's Paintings and Photographs*, Catalogue, Cooling Galleries November 1927

56 'Art Exhibitions, Mr Cecil Beaton' *The Times* 24 November 1927

57 see note 55

58 *British Journal of Photography* 2 December 1927 page 718

59 for the 'Great Lovers of Romance' matinée, see *Eve* 11 May 1927 page 314

60 see note 58

61 see note 55

62 see, for example *Eve* 19 January 1927 page 127 and 14 September 1927 page 514

63 see, for example *British Journal of Photography* 21 January 1927 page 39

64 E J Hobsbawm *Industry and Empire* 1969 page 153

65 Susan Sontag 'Notes on Camp' *Against Interpretation* New York 1966 page 288

66 *The Graphic* 26 November 1927 pages 268–9

67 Cecil Beaton *The Book of Beauty* 1930 page 9

68 Francis Bruguière 'The Artist Should Plan for Photography' *Photography* December 1933 page 18

69 'Man Ray' *The Listener* 28 November 1934 page 905

70 *The Photographic Journal of the RPS* July 1930 pages 228–335

71 *The Photographic Journal of the RPS* April 1932 pages 148–162

72 *The Photographic Journal of the RPS* April 1933 pages 138–149

73 ibid

74 see note 71

75 A Shaw Wildman *Unpublished Typescript* 1973

76 see note 72 pages 142–3

77 *Transition* November 1929 pages 123–9

78 ibid

79 Walter Nurnberg 'Advertising Photography' *Photography as a Career* 1944 page 77

80 see note 67

81 A Shaw Wildman in Conversation with the Author and Terence Pepper, January 1980

82 *Bystander* 4 January 1933

83 *Vogue* 31 May 1933

84 A Y McPeake in Conversation with the Author and Terence Pepper, April 1980

85 see 'April' *Harper's Bazaar* April 1937 page 73

86 *Harper's Bazaar* June 1936 page 26

87 *Harper's Bazaar* March 1938 page 42

88 'Transparencies' *Harper's Bazaar* February 1935

89 *Harper's Bazaar* October 1934 pages 64–5

90 *Architectural Review* December 1931

91 'Anatomy of Nathalie Paley' *Harper's Bazaar* September 1934 pages 52–3

92 They were published in *the Bystander*, throughout 1938

93 F J Guttmann 'When the Dreamer is a Craftsman' *Photography* December 1934 page 2

94 'The Sur-Realists' *Harper's Bazaar* March 1931 page 77 and 'An Italian Modern' *Harper's Bazaar* April 1931 page 67

95 *Photography* January 1936 pages 2–3

96 Jennings was one of the few in Britain to purchase a copy of Walker Evans *American Photographs* (1938)

97 see David Mellor 'Mass Observation – The Intellectual Climate' *Camerawork* Number 11 pages 4–5

98 Raymond Mortimer 'Introduction' *The English at Home* 1936 page 7

99 Bill Brandt, in conversation with David Mellor and Michael Regan December 1979

100 see note 98 page 34

101 Louis Aragon quoted in S W Taylor's Introduction; 1970 to Louis Aragon *Paris Peasant* 1980 page 16

102 see 'Whitechapel' *Picture Post* 15 October 1938 pages 23–28 ('*Picture Post* turned a cameraman loose in Whitechapel. He was to stay there as long as he pleased and come back only when he had the whole character of Whitechapel in pictures')

103 see 'La Boutique Dont Elle Sera La Plus Belle Ornement' *Minotaur* volume II number 5 1935 page 18

104 see *Studio* September 1935

105 see note 54 and Phillipe Soupault 'Preface' *Photographie* 1931 Paris; and also see Brian Howard's citation of Soupault's preface in 'Le Sang d'un poete' *Harper's Bazaar* April 1932 page 32

106 ibid Brian Howard

Note
Measurements are given in centimetres, height before width. Unless otherwise stated all photographs are vintage prints.

Biographical information given deals with the period 1919–1939.

Biographical details and list of exhibits

SIR CECIL BEATON (1904–1980)
Born in London, educated at Harrow and Cambridge where he took up photography. Work regularly appeared in illustrated society magazines from 1925 onwards. First major exhibition December 1927 at Cooling Galleries. British representative to Stuttgart Film & Foto exhibition 1929. Published *Book of Beauty* (1930). From 1927 until late 1930s becomes full-time contributor to Vogue.

The Sitwells 1927
10·2 × 19·9 Lent by Sotheby's Belgravia

Edith Sitwell 1927
24·2 × 18 Lent by Sotheby's Belgravia

Paula Gellibrand 1928
25·3 × 14·9 Lent by Sotheby's Belgravia

Piatogorsky circa 1930
22·4 × 18·9 Lent by Sotheby's Belgravia

Nancy Cunard circa 1930
18·9 × 23 Lent by Sotheby's Belgravia

Fred and Adèle Astaire circa 1930
45·7 × 36·7 Lent by Sotheby's Belgravia

Hat Check Girl, New York 1937
19 × 24·2 Lent by Sotheby's Belgravia

MAURICE BECK (1886–1960) and HELEN MACGREGOR
Beck trained as engineer. After time in Shanghai serving in the Chamber of Commerce where he took up photography returned to London to set up studio in Marylebone Mews with Helen MacGregor. Major exhibition of 250 photographs at the Piccadilly Hotel November 1923. Chief British photographers for *Vogue* in the 1920s specialising in portraits of Bloomsbury personalities as well as contributing still-life and fashion photographs to the *Sphere*. In the 1930s Beck was official Shell Mex and B.P. photographer while MacGregor specialised in theatre and fashion photography.

Nude Composition circa 1928
26·3 × 34 Lent by the Royal Photographic Society

HELEN MACGREGOR

Jacob Epstein 1925
20·4 × 15·2 Modern print from 'Photograms of the Year'

Louise Hampton in Late Night Final 1931
20·4 × 15·2 Modern print from 'Photograms of the Year'

Portrait of Mrs Conrad Veidt 1934
24·5 × 18 Private collection

OSWELL BLAKESTON (born 1907)
Avant-garde photographer and film-maker, critic, painter and novelist. Collaborated with Francis Bruguière on abstract film *Light Rhythms* 1930.

Seven Experimental Compositions circa 1927–30
6: 8 × 5·4; 1: 7·8 × 10 Lent by Oswell Blakeston

Rayograph circa 1929
25·2 × 20·1 Lent by Oswell Blakeston

BILL BRANDT (born 1907)
Born in London, educated in Germany; studied with Man Ray in Paris 1929–30. Returned to England 1931 and began photographing a cross-section of British social strata. Work published in *Weekly Illustrated* and books *English at Home* (1936) and *Night in London* (1938). Exhibited at Arts et Metiers Graphiques, Paris, 1938.

Coach Party: Royal Hunt Cup Day, Ascot 1933
23 × 19·7 Lent by Bill Brandt

Tic Tac Men at Ascot 1934
23 × 19·7 Lent by Bill Brandt

A Snicket in Halifax 1937
23 × 19·6 Lent by Bill Brandt

East End Girl Dancing the Lambeth Walk 1938
23 × 19·9 Lent by Bill Brandt

FRANCIS BRUGUIÈRE (1879–1945)
Born in San Francisco. Met Steiglitz in New York in 1905 while studying photography with Frank Eugene. Took up theatrical photography in New York in 1920s. In 1928 settled permanently in Britain and also exhibited at Der Sturm Galleries in Berlin. Collaborated with Lance Sieveking and Oswell Blakeston on avant-garde photo-books and abstract film 1929–30. Worked with McKnight Kauffer in commercial advertising in early 1930s. Exhibition at Lund Humphries 1933.

Design in Abstract Forms of Light 1925–7
33·5 × 25·4 Private Collection

Cut Paper Abstraction 1929
35·3 × 28 Private Collection

Cut Paper Abstraction 1929
23·9 × 18·6 Modern print from the original negative
Private Collection

Lloyd George circa 1931
27·9 × 35·9 Private Collection

Sky Scraper, New York 1932
33·8 × 23 Private Collection

HOWARD COSTER (1885–1959)
Born in the Isle of Wight. Opened London Studio in 1926, after working in South Africa, as self-styled 'Photographer of Men'. Portraitist of leading male figures in British life until 1944 working first for *The Bookman* and then *The Bystander*. Commercial work included photo-murals for Kodak and advertising photography for Lever Brothers and Brylcream. Fashion photographs in early 1930s with his wife Joan Coster for Vogue. Major one-man exhibition at Selfridges in 1937.

G. K. Chesterton 1926
29·1 × 24·5 Lent by the National Portrait Gallery

Edgar Wallace 1930
22 × 23 Lent by the National Portrait Gallery

T. E. Lawrence 1930
30·5 × 24 Lent by the Royal Photographic Society

The Lost Pleiad circa 1932
27·3 × 21·3 Lent by the Royal Photographic Society

Photomontage for SKF Ball Bearings 1934
33·7 × 27·9 Collage on card, borders inscribed in pencil
Lent by the National Portrait Gallery

CRAWFORD STUDIOS

The Weekend 1928
34·2 × 26·8 Commissioned by Worthington Bass Charrington
Lent by the Bass Museum, Burton on Trent

JOHN EVERARD
Commercial and portrait photographer with studio in Orange Street, Haymarket, London in early 1930s. Published in 1937 *Seen in England* a collection of candid photographs of urban types many of which first appeared in *The Bystander*. In 1939 formed the Photo-Centre with Walter Bird and Roye.

Murdoch Beaton 1935
36·2 × 24·6 Lent by the Royal Photographic Society

NOEL GRIGGS
From circa 1931 Griggs was chief photographer of Logan, a leading London commercial and industrial photographic studio. Exhibited at Art Center exhibition of Foreign Photography, New York 1933. Appointed Studio Director of Studio Briggs 1935. Exhibited 1937 Museum of Modern Art, New York.

Chimney 1932–3
51 × 39 Lent by the Royal Photographic Society

Battersea Power Station 1932–3
50·2 × 39·7 Lent by the Royal Photographic Society

JOHN HAVINDEN (born 1909)
Brother of designer Ashley Havinden. Educated at Oundel School, apprenticed as a carpenter in France in early 1920s. Began photographic career in Australia before returning to London in 1929. Formed Gretton Photographs 1930: Gretton Photo 1932, as studios for commercial and colour photography. Throughout 1930s intensive advertising work, especially for Crawfords agency.

Foto (self portrait) 1929
24 × 19·2 Modern print from the original negative
Lent by John Havinden

Glass Rods of Light circa 1930
37·7 × 30·2 Lent by John Havinden

H.M.V. Records and Players circa 1932
20·8 × 17·2 Commissioned by Winter Thomas for H.M.V. Co.
Lent by John Havinden

Gretton Photo Promotional Card circa 1935
33 × 25·7 Lent by John Havinden

Time: Per Annum 1936
36·2 × 28·4 Lent by John Havinden

Beach Sculpture IV 1937
20·3 × 28·2 Lent by John Havinden

Standard Cars Advertisement 1939
17·7 × 20·7 Commissioned by Winter Thomas for Standard Cars
Lent by John Havinden

E. O. HOPPÉ (1878–1972)
Born in Munich. Settled in London circa 1900 becoming a professional photographer in 1907. By 1913 he was the leading London portraitist. Major one-man exhibition at RPS in 1910 and in 1922 at Goupil Gallery. Pioneered the use of photographs in advertisements in 1920s and began travels in Europe and America producing a series of successful travel books. He published his autobiography *100,000 Exposures* in 1945.

Flower Seller 1921
18·7 × 13·4 Lent by the Mansell Collection

The Romance of Steel 1925
38·8 × 49·6 Lent by Frank Hoppé

Berlin Interior 1928
22·9 × 29·1 Modern print from the original negative
Lent by the Mansell Collection

Berlin Steps 1928
39 × 30·5 Modern print from the original negative
Lent by the Mansell Collection

Skeleton Foot, Berlin 1928
22·9 × 29·1 Modern print from the original negative
Lent by the Mansell Collection

HUMPHREY JENNINGS (1907–1950)
Educated Pembroke College, Cambridge. Painter, film-maker, poet and photographer, he began work with the G.P.O. film unit in 1934. Co-organiser of International Surrealist exhibition, London 1936; co-founder of Mass Observation, 1936. Experimented with 35mm photography in late 1930s.

Woman's Head and Fire Place circa 1936–8
24·5 × 37·5 Lent by Charlotte Jennings

Daily Worker and Floor circa 1936–8
24·6 × 37·5 Lent by Charlotte Jennings

Portrait of Roger Roughton circa 1936–8
24·8 × 37·4 Lent by Charlotte Jennings

BARBARA KER-SEYMER (born 1905)
Trained at Chelsea School of Art from 1922. Assistant to society
portrait photographer Olivia Wyndham in 1929. Began
independent portraiture the following year. 1932 set up studio in
Kings Road, Chelsea. From 1931 worked for Harper's Bazaar. In
late 1930s worked for Colman Prentis advertising agency.

Nancy Cunard 1930
23·2 × 16 Lent by Barbara Ker-Seymer

Portrait of Julia Strachey (The Hon. Mrs Stephen Tomlin) 1930
30·4 × 23·4 Lent by the National Portrait Gallery

Portrait of Sandy Baird circa 1931
24·5 × 30·5 Modern print from the original negative
Arts Council Collection

HERBERT LAMBERT (1881–1936)
Succeeded his father in his portrait photography business in Bath
in 1900. Published *Modern British Composers* (1923). Regular
exhibitor at the London Salon of Photography from 1910 onwards.
One-man exhibition at Camera Club, London 1924. Appointed
managing director of Elliott & Fry in 1926.

Girl's Head circa 1920
24 × 22·3 Lent by the Royal Photographic Society

Sir Malcolm Sargent 1924
19·8 × 13·9 Lent by the Royal College of Music

ANGUS MCBEAN (born 1904)
Born in Newport, South Wales. From 1933–4 he learnt the
techniques of photography as an assistant in Hugh Cecil's Grafton
Street studio before moving to his own studio in Belgrave Street,
Victoria in 1935. Close contact with London theatre life, made
masks for 1936 Ivor Novello production of *The Happy Hypocrite*.
Contributed a weekly series of surrealist portraits to the *Sketch* from
December 1937.

Beatrix Lehman 1937
29·1 × 22·8 Lent by the Impressions Gallery

Flora Robson 1938/9
29·1 × 24·1 Lent by the Impressions Gallery

Francis Day 1938
29·2 × 24 Lent by the Impressions Gallery

ROSALIND MAINGOT
Born in Brisbane, Australia. Took up photography after training
at London Polytechnic School of Photography. Became an
Associate of the Royal Photographic Society in 1932. 1933 one
woman show at Camera Club. Regular and prolific exhibitor at
both RPS. and London Salon. Early worker in colour photography.
Died in 1957.

Chrysalis 1933
49·2 × 39·4 Lent by the Camera Club

CURTIS MOFFAT (1887–1949)
Born in New York. After working with Man Ray in Paris, opened
studio in London in 1925. With Olivia Wyndham as assistant
staged a joint exhibition at the Bond Street Galleries 1925, and
also in 1926 exhibited at the Brook Street Galleries. After a period
in America he returned again to London to establish an interior
decorating firm in Fitzroy Square. Experimented with colour
photography in mid-1930s and had an exhibition of colour still-
lifes, Mayor Gallery 1935.

Rayograph 1924
37·8 × 30·3 Lent by Mrs Curtis Moffat

Rayograph 1924
37·5 × 29·9 Lent by Mrs Curtis Moffat

Nancy Cunard and Louis Aragon, Paris circa 1926
27·3 × 49·2 Modern print taken from the original negative
Lent by Mrs Curtis Moffat

Artist and Industry (Frank Dobson, Jeanne de Casalis with
Charnaux Models)
20 × 26·3 Copy print from Harper's Bazaar March 1934

Piano Abstract 1935
24·4 × 18·7 Lent by Mrs Curtis Moffat

The Closed Book 1935
38 × 37 Lent by Mrs Curtis Moffat

Colour Abstract (Compass and Egg) 1935
18·6 × 13·5 Lent by Mrs Curtis Moffat

WARD MUIR (1878–1927)
Born in Derby. Took up photography circa 1890. First shown at
the Photographic Salon in 1901 he was elected a member of the
Linked Ring in 1904. Exhibited at the RPS and was also an early
member of the London Salon of Photography. Immediately after

World War I became an advocate of 'straight' photography. Also a critic and novelist.

June Evening circa 1920
23·2 × 34·6 Lent by the Royal Photographic Society

JOHN SOMERSET MURRAY (born 1904)
A grandson of John Murray, calotypist of India, and cousin of the portraitist Olive Edis, he opened his own portrait studio in Chelsea in 1933. Shortly afterwards turned to commercial photography including work for Pilkington Glass 1933–9. With Winifred Casson (died 1970) executed solarised and surrealist photographs which were shown at the Chelsea Studio Club in March 1935. Later took up electronic engineering.

Portrait of Winifred Casson circa 1934
22·5 × 17 Lent by John Somerset Murray

Nude Study in Sepia circa 1935
15·5 × 20·2 Lent by John Somerset Murray

Artwork for May 1935 cover of Photography Magazine
36·9 × 29 Lent by John Somerset Murray

Surrealist Study 1935
(with Winifred Casson)
24 × 23·8 Lent by John Somerset Murray

Vicuna Coat for Fortnum and Mason's Catalogue 1939
29·1 × 16·7 Lent by John Somerset Murray

PAUL NASH (1889–1946)
After a successful career as a painter, book illustrator and designer Paul Nash took up photography in 1930 and took photographs for his private use to supplement his pictorial activities continuing until his death in 1946.

Dead Tree, Romney Marsh circa 1932
30·5 × 16·6 Modern print from the original negative
Arts Council Collection

Dead Tree, Romney Marsh circa 1932
30·5 × 16·6 Modern print from the original negative
Arts Council Collection

Dead Tree, Romney Marsh circa 1932
30·5 × 18·3 Modern print from the original negative
Arts Council Collection

Avebury Stone 1933
17·7 × 30·5 Modern print from the original negative
Arts Council Collection

Mary Godwin, Oxford circa 1939
30·5 × 18·7 Modern print from the original negative
Arts Council Collection

WALTER NURNBERG (born 1907)
Born in Berlin. Arrived in London in 1934 initially renting studio in Aldwych House. He propagated the German Neue Sachlichkeit photography through articles in *Commercial Art* and *Photography* magazine and by the example of his own commercial work. Member of the Reiman School faculty from 1937.

Hand Drill 1934
21·5 × 30·5 Modern print from the original negative
Lent by Walter Nurnberg O.B.E.

Cigarettes and Tobacco 1936
26 × 18·6 Modern print from the original negative
Lent by Walter Nurnberg O.B.E.

Players advertisement 1937 *'Players are always in the Picture'*
30·2 × 22·1 Modern print from the original negative
Lent by Walter Nurnberg O.B.E.

BERTRAM PARK (1883–1972)
Began photographic career as an amateur before becoming a professional portraitist. Set up studios at 43 Dover Street in 1919 with Marcus Adams and Yvonne Gregory (his wife since 1916). Founder member of London Salon of Photography in 1910 and secretary 1911–1916. Published *Living Sculpture* with Yvonne Gregory in 1926 and in 1930 pioneered carbro colour prints at the salon.

Dazzle Jazz Rags, (portrait of Mrs Bertram Park) 1919
20·4 × 14·5 Lent by the National Portrait Gallery

Dazzle Jazz Rags, (portrait of Mrs Bertram Park) 1919
20·4 × 14·5 Lent by the National Portrait Gallery

C R W Nevinson 1919
29 × 23·3 Lent by the Camera Club

Ward Muir 1920
30 × 22·8 Lent by the Camera Club

Nude Study circa 1930
30·1 × 19·7 Lent by the Camera Club

Nude Study circa 1930
27·6 × 36·2 Lent by the Camera Club

NORMAN PARKINSON (born 1913)
Born in Roehampton. Educated at Westminster School. Began photographic career working for Court Photographers Speaight 1931–3 in Bond Street. Opened own studio at 1 Dover Street in 1934. Worked extensively for *The Bystander* and *Harper's Bazaar* 1935–9. His photographs formed the basis for Francis Bruguière's British Pavilion photo-mural at Paris Exhibition in 1937.

Outside the Palace 1936
(Fashion photograph for *Harper's Bazaar* June 1936; clothes by Reville-Terry and Hartnell)
29·3 × 21·6 Lent by A Y McPeake

News in London 1938
(Fashion photograph for *Harper's Bazaar* March 1938)
24·5 × 18 Lent by A Y McPeake

Let's Go Skiing 1938
(Fashion photograph for *Harper's Bazaar* December 1938)
32·1 × 44·5 Lent by A Y McPeake

Viola Redfern's Joseph's Coat
Modern print from April 1939 *Harper's Bazaar*.

Wolsey Swimsuits
Modern print from June 1939 *Harper's Bazaar*.

PETER ROSE PULHAM (1910–1956)
Born in Pulham, Norfolk. Educated at Worcester College, Oxford and the Architectural Association. Began photography in July 1930 and fashion photography from 1931 working mainly for *Harper's Bazaar* contributing essays and photographs until 1938 when he abandoned photography for painting in Paris.

Fashion Study circa 1936
26·9 × 15·9 Lent by Mrs M Ryan

Page proofs for double page spread in May 1936 *Harper's Bazaar*:
A Reville-Terry dress designed by Elspeth Champcommunal;
B Paquin Dress
Lent by A Y McPeake

Skating Scene circa 1937
24 × 28·5 Lent by A Y McPeake

Bébé Bérard with Hand Raised 1938
17·1 × 16·3 Lent by Mrs M Ryan

Double Exposure Nude circa 1938
24·6 × 24·2 Lent by Mrs M Ryan

Jean Cocteau 1937–8
27·5 × 25 Lent by Mrs M Ryan

EDWIN SMITH (1912–1971)
Born in Camden Town, London. Won R.I.B.A. scholarship 1930. Worked in Marshall Sisson's drawing office 1932. Began photography 1935 worked in London and the North of England in the second half of the 1930s concentrating on architectural and documentary photography.

Court Hairdresser, Dover Street 1935
24·5 × 17·6 Lent by Olive Smith

Fairground Horses 1935
24·5 × 17·6 Lent by Olive Smith

Northumberland, Ashington Collier 1936
25·3 × 17·9 Lent by Olive Smith

Northumberland, Ashington Collier 1936
25 × 17·1 Lent by Olive Smith

Northumberland, Ashington Collier 1936
24·2 × 15·8 Lent by Olive Smith

Elm Tree, December 1936
17·4 × 25·2 Modern print from the original negative
Lent by Olive Smith

Mrs Denwood's House, Scotswood on Tyne 1936
16 × 24·8 Lent by Olive Smith

Northumberland, Ashington Colliery 1936
25·4 × 17·1 Lent by Olive Smith

Miner's Interior, Newcastle 1936
24·8 × 18·1 Lent by Olive Smith

HUMPHREY SPENDER (born 1910)
Introduced to photography as a child by his brother Michael.
Studied in Freiburg and at Architectural Association. Rented
studio in the Strand with William Edmiston collaborating with
him on portraits and vanguard photographs. Became 'Lensman'
for the *Daily Mirror* 1934 and Mass Observation photographer
1937–9. From 1938 worked as a *Picture Post* photo-reporter.

Four versions of the *Goodbye to Berlin* book-jacket circa 1930
A 20·6 × 14
B 20·6 × 14
C 20·3 × 14
D 19·4 × 13·3
Lent by Humphrey Spender

Portrait of Christopher Isherwood, London 1930
24·7 × 18·2 Lent by Humphrey Spender

Be-ringed Hands 1933–4
(with William Edmiston)
14·7 × 20 Lent by Humphrey Spender

Street Organist at Public House Door 1938
24·6 × 16·5 Lent by Humphrey Spender

St James's Park, London 1938
14·3 × 22 Modern print from the original negative
Lent by Humphrey Spender

Hand at the Window 1938
14·3 × 21·9 Modern print from the original negative
Lent by Humphrey Spender

PAUL TANQUERAY (born 1905)
Educated Tonbridge school, 1923 became pupil in Hugh Cecil's
Grafton Street Studio. Set up his own studio at 139 Kensington
High Street in 1924. Specialised as portraitist for society and
theatrical clients working especially for *Theatre World*. Contributed
photographs to *Bystander*, *Harper's Bazaar* and *Sketch*. In 1930
moved to 8, Dover Street. One man shows in 1930 and 1935.

Ivor Novello 1928
38·2 × 30·5 Modern print from the original negative
Private collection

Anton Dolin 1928
30·1 × 33·9 Modern print from the original negative
Private collection

Tallullah Bankhead 1928
30·5 × 40·2 Modern print from the original negative
Private collection

EDITH TUDOR-HART (1908–1978)
Born in Vienna. Attended Bauhaus, Dessau in 1931. Settled
permanently in Britain 1933. Member of Workers Camera Club
exhibiting with Artists International Association from 1934. Work
for continental periodicals and *Geographical Magazine* and *Left
Review* in late 1930s.

Corset Shop 1935
24·4 × 24 Modern print from original negative
Lent by W Suschitzky

Cake Shop circa 1937
29·2 × 24·5 Modern print from original negative
Lent by W Suschitzky

DOROTHY WILDING (1893–1976)
Began her photographic career as apprentice to Marion Neilson
and later Richard N. Speaight before opening her own studio in
George Street, Portman Square in 1914. With success moved to
larger studios first to Regent Street and then to Bond Street in
1924. Appointed as first woman official royal photographer for
1937 coronation. Left London to set up second studio in New York
in 1937. Autobiography 'In Pursuit of Perfection' 1958.

Noel Coward 1925
43·2 × 31·7 Lent by the Royal Photographic Society

Diana Wynyard circa 1938
43·5 × 32·9 Lent by the National Portrait Gallery

A SHAW WILDMAN (born 1900)
Born in Accrington, Lancs. Served in R.F.C. After the War
entered Fleet Street as a typographer before taking up professional
photography in 1929 in Gordon Square. From 1932 he worked in
his own large studio at Heston with his assistant Bertram Follet for
a range of advertising commissions especially Kodak, British
Celanese and Harvey Nichols. In 1933 included in Art Center
exhibition of Foreign Photography in New York.

Sylvia Ironside Chin Reducer (model Natalie Sieveking) 1932
24·3 × 19·7 Lent by Shaw Wildman

Matita advertisement (Mrs Ronald Balfour with dogs) 1932
37·1 × 28·1 Lent by Shaw Wildman

Burberry at Brooklands (advertisement for Vogue 31 May 1933)
28·1 × 27 Lent by Shaw Wildman

Stepping in to 1937 British Celanese Advertisement
24 × 18·9 Lent by Shaw Wildman

Fashion Study British Celanese (Earthquake) 1938
37·3 × 28·7 Lent by Shaw Wildman

Fenwick Fashion Advertisement (model Margaret Wood) 1938
36·5 × 28·3 Lent by Shaw Wildman

Shaw Wildman wishes to acknowledge the skilled co-operation of his assistants in the production of these photographs and especially that of Bertram Follet who assisted him throughout the period 1929–1939.

MADAME YEVONDE (1893–1975)
Began career as pupil of Lallie Charles, the leading woman photographer of the day. Just before outbreak of war she opened her first studio at 92 Victoria Street. In the 1920s she promoted the cause for women photographers. In 1932 exhibited 'Colour and Monochrome Photographs' at the Albany Galleries. In 1933 moved to the West End opening a studio in Berkeley Square. 1935 Exhibition 'Goddesses and Others'. Autobiography 'In Camera' 1940.

Self Portrait circa 1925
19·8 × 24·2 Lent by the National Portrait Gallery

Mrs Michael Balcon as Minerva 1935
34 × 26·8 Lent by the National Portrait Gallery

Ariel 1935
36·5 × 29 Lent by the National Portrait Gallery

Lady Malcolm Campbell as Niobe 1935
29·8 × 37·6 Lent by the National Portrait Gallery

Mrs Mayer as Medusa 1935
36·3 × 29·8 Lent by the Royal Photographic Society

Four Colour Studies circa 1935
A 15·8 × 11·2
B 14·6 × 11·5
C 14·3 × 11·2
D 15·1 × 10·5
Lent by Ann Forshaw

Acknowledgements

We would like to join with David Mellor in thanking the following people who have assisted in the task of locating material for the exhibition or who have supplied valuable information for the catalogue: Hilary Allen, *Sothebys;* Bill Brandt; Claire Colvin, *Tate Gallery Archive;* Pat Doggett, *The Camera Club;* Rosalinde Fuller; Judy Goldhill; Mark Haworth-Booth, *Victoria and Albert Museum;* Geoffrey Large, *Harper's Bazaar;* Valerie Lloyd, *Royal Photographic Society;* A Y McPeake; Mrs Curtis Moffat; Robert Radford; Olive Smith; Paul Tanqueray; A Shaw Wildman; Val Williams, *Impressions Gallery of Photography.*

Cover illustration: Minerva by
Madame Yevonde, COURTESY
OF THE NATIONAL PORTRAIT
GALLERY

Back cover: The Lost Pleiad by
Howard Coster, COURTESY OF
THE ROYAL PHOTOGRAPHIC
SOCIETY

© Copyright Arts Council of Great Britain 1980

Exhibition organised by Michael Regan
assisted by Joanna Henderson
Graphics and catalogue design Judith Cramond
Printed by Syon Print

ISBN 0 7287 0246 0